THE BEADER'S GUIDE TO
SURVIVAL
BOOK

*Techniques for
Intrepid Beadlovers*

INTERSTELLAR
TRADING & PUBLISHING COMPANY

BEVERLY HILLS, CA

THE BEADER'S GUIDE TO SURVIVAL BOOK

ISBN 978-1-889599-25-0 / 1-889599-25-5
LIBRARY OF CONGRESS CATALOG NUMBER: 2006921500
SAN: 298-5829

ILLUSTRATIONS BY WENDY SIMPSON CONNER
PRINTED IN THE UNITED STATES OF AMERICA

VISIT OUR WEBSITE AT WWW.INTERSTELLARPUBLISHING.COM
INTERSTLR@AOL.COM
800-790-8730

FIRST PRINTING: SEPTEMBER, 2006

ACKNOWLEDGMENTS:
To Joni, Paul and my mom, Priscilla;
and everyone who bought and loved

THE BEST LITTLE BEADING BOOK,
THE BEADED LAMPSHADE BOOK,
THE MAGICAL BEADED MEDICINE BAG BOOK.
THE 'KNOTTY' MACRAME AND BEADING BOOK
THE BEADED WATCHBAND BOOK
THE CHAIN & CRYSTAL BOOK
THE BEADED JEWELRY FOR A WEDDING BOOK
THE CHILDREN'S BEADING BOOK
THE CAT LOVER'S BEADED PROJECT BOOK
THE WIRE BENDING BOOK
THE BEADING ON FABRIC BOOK
THE "AFTER 8" ELEGANT EVENING JEWELRY BOOK
THE BEAD LOVER'S BIBLE

INTRODUCTION

There's nothing more enjoyable than taking a class to learn a new beadwork project. Generally, you sit with a group of like-minded people, creating something you'll be proud to wear. Ideas and phone numbers are exchanged . . . a new support group is born!

The problem comes later at home, as you struggle to remember just what the instructor told you to do. Sometimes, you might watch helplessly as the necklace you were so proud of falls apart right in front of your eyes! You call the others in the class, and they are having the same experience.

I've received many frantic phone calls in the middle of the night (beaders are nocturnal, you know), asking how to give C.P.R. to a dying necklace. Like a "beader's ER", I've given phone instructions to help resuscitate the victim. What went wrong?

No matter how good the instructor or how thorough your notes, you are taking in a lot of information at one time, and it doesn't always stick the way it's supposed to. It's quite normal to get home and draw a blank. And, sometimes, even if we feel we've gotten the info, the "Powers That Bead" have other ideas, and your jewelry develops a rebellous streak.

What do you do if there's no one to call for help? How do you get the answers you need to finish your jewelry?

My students urged me to write this book. This is your "I'm-out-there-in-the-beading-wilderness-and-I-need-to-know-how-to-fix-this-problem" book. With techniques that range from making your own findings, to tightening a knotted necklace, to wire wrapping a bezel, to working with broken beads . . . a lot of ground is covered.

Every project in this book offers a little more than just making the project - it shows you ways to fix the snafus that come along. This is the book you might want to take with you to that desert island!

An exiting new aspect to this book is that we actually patented many of the techniques shown in this book! This is the first book that shows the patented processes. Don't worry - you can use these techniques in your own work for personal or professional use, but if you want to teach or reprint them, you have to get the publisher's written permission.

I hope you enjoy this book. This is part of a series of 25 books called **The Beading Books Series**™. Other books in the series include *The Best Little Beading Book, The Beaded Lampshade Book, The Magical Beaded Medicine Bag Book, The "Knotty" Macrame and Beading Book, The Beaded Watchband Book, The Chain & Crystal Book, The Beaded Jewelry for a Wedding Book, The Children's Beading Book, The Cat Lover's Beaded Project Book, The Wirebending Book, Beading on Fabric Book, The "After 8" Elegant Evening Jewelry Book* and *The Bead Lover's Bible.*

As always, I love hearing your wonderful comments. Please feel free to write to me c/o The Interstellar Trading and Publishing Company, P. O. Box 7306, Beverly Hills, CA 90212.

You can also email me at Interstlr@aol.com, or visit our website at www.interstellarpublishing.com

"Me"

TABLE OF CONTENTS

PUBLISHER'S NOTE: *We hold patents on many of the techniques shown in this book. If you would like to reprint or teach these methods, please contact us at 310/247-8154 to obtain written permission.*

ANATOMY OF A NECKLACE

Think of a necklace like a line segment: it has a beginning, a middle, and an end. The middle is the easy part - just string the beads in any order you like. The difficult part is the ends - how do you know what the best materials and techniques are to keep your necklace together? What materials are compatible?

It's really not that hard to figure out. There are common materials that you can find in any bead or craft store. The materials in themselves are just fine - what literally makes or breaks a necklace is the way you combine them.

A "finding" is anything that is not a bead - your clasps, knot covers, crimp beads, etc. There are rules about what finding works best with what stringing medium. Although sometimes it's fine to break the rules, it just makes good sense to combine the right things and minimize breakage.

For instance, a cable (commonly known as Softflex™, Beadalon™, "Tiger Tail", etc.) works best when used with crimp beads to hold your ends in place (more on this on page 33). This is used when you need something stronger - either your beads are heavy or sharp; this jewelry will see a little more action than most pieces: you want to swim in it or wear it for soccer practice; it's an anklet or your new tennis bracelet.

These cables are not meant to be delicate; I don't recommend knotting them for aesthetic purposes. These differ from a wire because they are usually a bundle of tightly braided wires covered in a nylon conduit. Because they are basically wires, they will "scar" and remember a bend. It's not easy to smooth out a kink once it's in the cable.

Whereas cables are meant to be used for linear stringing, plain wire is not. It will break, or the wire will cut the wearer. Good old wire is meant to be bent and manipulated into lots of fun shapes for unusual clasps, bezels, earring designs, and more.

If you want to make a necklace or bracelet a little finer or stylish, using a fiber (silk thread is the preferred medium) will get you a nicer product. When you want to knot between your beads, this is the way to go. You don't use crimp beads with silk thread - it shreds it. Instead, you use either knot covers (also known as bead tips) or French Bullion (also known as French Coil). Both of these techniques are shown on pages 6 and 7.

And as for elastic plastic cording - I can bet you it will always break. Sure, it's easy to wear jewelry made on elastic, but sooner or later, you will hear the sound of your beads hitting the floor. It's a great way to keep the grandkids occupied on a rainy day, but aside from cheap plastic, I would never dream of putting anything of value on it.

By the way, all of the above refers to bracelets as well as necklaces. The only big difference (and it is a big one) is the choice of the clasps. Necklaces can use a large variety of clasps - toggles, lobsters, pearl, fish hook, etc. because the weight of the beads will hold the necklace together. Bracelets are a whole other story, because they have a smaller quantity of beads on them, they tend to weight less. They are also constantly in motion, so some of the more temperamental clasps won't work. Don't use a toggle clasp on a bracelet - you have a very high chance of it coming undone.

Also, unless you have a personal maid who dresses you, the odds are you're putting on your own bracelet. Fussy clasps that require two hands are a little awkward. Lobster clasps can be manipulated one-handed; a lot of my clients love the new magnetic clasps because they hold together so well. If you are making your jewelry to sell, these are considerations to increase your sales.

BULLION VS. KNOT COVERS
CLAMSHELLS VS. KNOT CUPS

Decisions, decisions! Which is the best to use for each situation?

BULLION Also known as French coil, this little coil is actually made of wire. It's used when you want the look of traditional fine jewelry, usually with pearls, but not with heavy beads.

STEP ONE:
Thread one of your beads to almost the end of the thread (don't worry about the details of the thread right now, this is just the part about using bullion. The rest of the info follows).

Bring the bead down almost to the end of the thread (about 3" from the end is good.

You can always use a little scotch tape at the end to keep the bead from falling off.

STEP TWO:
Cut a length of bullion about 1/2" long. Be careful, as it is pretty delicate and if it pulls out, it becomes a very long kinked up wire. It sort of looks like a very tiny straw. It acts as a conduit to protect your thread from wear and tear so it won't break. Carefully thread it onto the needle. As you move it down the thread, be sure to push it and not pull it (this will help it keep its shape. Carefully push it all the way down to the bead that is almost at the end of the thread.

STEP THREE:
This is the part where it gets a bit tricky. You need to make a loop with the bullion, and add your clasp (A). Knot the thread where the bullion comes back together (B), and bring the needle back through the same bead IN THE OPPOSITE DIRECTION from the first time you threaded it on. Make a knot (C) and continue on.

You are now ready to start knotting with the technique shown on page 8. Finishing instructions are on page 17.

BULLION VS. KNOT COVERS
CLAMSHELLS VS. KNOT CUPS

And in this corner, we have knot covers . . .

KNOT CUPS This is another variation of ending your jewelry. It works great on both necklaces and bracelets. It's not meant to be super heavy duty: your knots will show and it has a more delicate look than clamshells. You may have heard these called "bead tips".

STEP ONE:
Start by making an overhand knot about 3"
from the tail end of the thread (NOT the end with the
needle). You can put scotch tape on this end to secure it to the table.

STEP TWO:
You want to add your knot cup at this point. The knot that it is supposed to cover
is the one you just made in the thread. It is important that it's put on in the right direction,
because the little hook needs to attach to the clasp. The needle goes into
the cup and out of the rounded end. This way the hook faces outward
on your necklace and the knot is covered. Bring the bead tip
all the way down to cover that knot. Now you are ready to string your beads -
this works for both knotting and just straight stringing. When you are
done with the beads, you will add another knot cover
for the other end. This second one will go on in the
opposite direction. Knots at both ends will be cemented.

3-4"

CLAMSHELLS These work exactly the same way as the knot cups, but the advantage is that you can hide your less-than-perfect knots inside the clamshell. Once you are completely done with your necklace, the knots inside the clamshell are cemented and the clamshell is closed.

Just as shown above, the
needle goes into
the first clamshell, and
then it is brought down
to the tail end of the thread.

THE WORLD'S EASIEST WAY TO KNOT BETWEEN BEADS

Why knot? There are lots of good reasons: if the necklace breaks, you only lose one bead; it extends the length of the strand you're working with, so you use fewer beads; my favorite reason is that it adds a sense of style to your work. Knotting between beads is the mark of a fine necklace. People appreciate the work involved, and it sets you apart from other jewelry designers who don't knot. Knotting adds a richness, and the colors of the thread add a dimension to the design. Unless you're working with traditional white pearls, think outside the box when it comes to colors of silk - the knots will read as little tiny beads, so you can have a lot of fun in designing with your silk thread as a part of the concept.

So, who said it had to be hard? This patented method will cure your knotting headaches - yes, you too can knot in a professional manner that won't require a nervous breakdown! Just take it step by step!

First of all, *choose your supplies*. It's best to pick out our beads first, and build the necklace around them. Then, we select the thread. I like the silk thread that comes on cards, because it eliminates the time to thread the needle - each card of silk thread comes with its own needle, already attached. This is a collapsible eye needle, and just needs to be straightened out when you open the package, and it's ready to go. There's about seven feet on there, so you can get two to three projects out of each card.

As for the thickness of the thread: *calibrate your thread size to the size of the hole in the bead*. Your goal is to fill up the hole as much as possible to eliminate friction, which will eventually make the necklace break. You want the knots you make to be the perfect size - they should not disappear into the hole of the bead, but they should not be as big as your beads are. If you have picked a thread that needs to be knotted twice in one spot (double-knotted), ditch it and get something thicker. Just like lightning striking the same place twice, it takes great patience to make your knots hit perfectly one on top of the other in a double knot. If you are stringing beads with varying size holes, please see page 20.

By the way, this technique works with every thread in every thickness, from the finest silk to the heaviest leather.

YOU WILL NEED:
- Thread with a needle
- Sharp jeweler's tweezers that DO NOT have teeth inside
- Beads of choice
- Scotch tape
- A small ziplock bag (appx. 3x4")
- Findings and beads
- A small card (appx. 2x2")

NOTE: The term "necklace" is used here, but this techniques works with anything you make!

STEP ONE:
- If you are using thread on a card, remove it completely from the card. **-OR-**
- If you are using thread from a spool, measure a length that is five times the length of the desired necklace (for example, if you want to make a 16" necklace, cut a piece that is 80" long). Thread a needle, and bring both tails together.

STEP TWO:
Decide which findings you will use at your ends - either bullion, knot cups, or clamshells. You will need 2 of each for each necklace (Two knot cups **OR** two clamshells, etc.). Prepare the beginning as shown on pages 6 and 7. (Most people choose knot covers, so this is what the diagrams will depict. However, the technique is the same for however you choose to end the necklace).

KNOTTING

STEP THREE:

If you are right-handed, you will probably want to hold the tweezer in your right hand. So, that means you need to tape that little 3" tail at the end of your thread on your right side. Now, there is no absolute here, and you may decide it works to tape it elsewhere. This is what I found works best for me, and is a suggestion to get you started.

About two feet away from that first piece of tape, you're going to tape the thread down again. Why, you ask? Because what makes this method goof-proof is the way that we pre-thread the beads on before we start knotting. If we don't add this second piece of tape, we'll forget as we add the beads and bring them down to the knot cover. We need a good two feet of empty thread to manipulate as we make our knots.

tape #2

tape #1

knot with clamshell

STEP FOUR:

You are ready to thread all of your beads on, bringing them down as far as the second piece of tape.

They need to be in the exact order you want them to end up, as once they're strung, you would need to take the beads off to rearrange them.

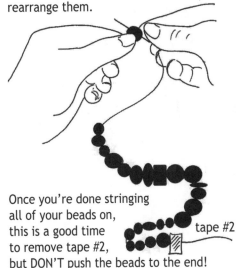

Once you're done stringing all of your beads on, this is a good time to remove tape #2, but DON'T push the beads to the end!

tape #2

STEP FIVE:

Now that you have your beads on the thread, you need to make them controllable or you will go crazy with them. Also, if we leave the thread as a long, free-range string, the odds of tangling are very high, and you'll end up with unwanted knots.

So, now you will wrap the thread (beads and all) around a small card. Start with the needle on the card, and continue, so the beads will feed off the card from the side facing the knot cover, as that is the direction we will be working from. There should still be about two feet between the card with the beads and your knot cover.

KNOTTING

STEP SIX:

This is the part that makes it worth the "E" ticket! The card, beads, thread and all goes into a little ziplock bag. This is now the "dispenso-bead-o-matic" that lets you knot with confidence, like a pro, and tangles and knots are not a worry! With everything tucked tidily into the bag, you are free to concentrate on making the perfect knot.

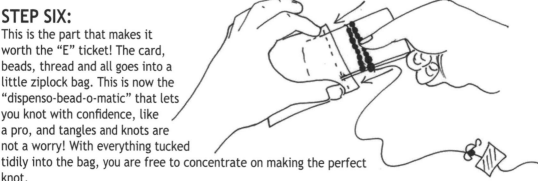

STEP SEVEN:

This is the easiest way to make your knots. You may want to modify this to suit your own style, but the most important thing is that you always make your knots in the same direction, so that the necklace will hang correctly.

(A) Position the bag on the left and the taped knot cover on the right.

(B) Bring the bag down toward you on the table.

(C) Bring the bag UP and OVER the thread in a perpendicular way.

(D) Almost like making a pretzel, bring the bag through the loop in an "under / over" motion.

Set the bag down and pick up your tweezers (The right tweezers are very sharp, and you are better off making your loops without the tweezers in hand).

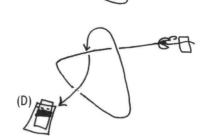

KNOTTING

STEP EIGHT:

Lay the loop you just made over where you want the knot to be (just where it comes out of the knot cover). With your tweezers, grab the thread as close as possible to the knot cover (pushing back - that is the secret of making a nice, tight knot. Everything loosens up in the end, and it just makes sense to work as tightly as possible. There are tips later in this book for loosening up knotwork that is too tight. It's harder to tighten than it is to loosen. Work with the tip of the tweezer, and keep in mind the knot will end up wherever the tip of the tweezer is, as long as you have the loop arranged around it. Think of it like a little "snare trap".

 Keep pulling until the knot is tight around the tip of the tweezer, than CAREFULLY ease the tweezer out. It you open the tip of the tweezer or pull too hard, the knot will jump, and then you have to deal with opening it up and moving it! If you just "wiggle" the tweezer out of the loop, the knot will stay tight.

STEP NINE:

The reason we work with a tweezer, rather than a pin, is that the tweezer gives us so much more control over the placement of the knot. One last step that really is critical is to tighten the knot with the tweezer. Just push back on the thread as shown, but not with the tip of the tweezer, because that can break your thread. About 1/2" up the tweezer is fine, and by pushing back the knot you are tightening it, so it can't pull out and stretch.

STEP TEN:

Pull a bead out of the bag and bring it all the way down to your knot. Repeat from STEP 7, alternating adding beads and making knots. When you have used up all your beads, add the second knot cover, make the same overhand knot that you've been making, but this one is trickier because it has to go inside the knot cover.

STEP ELEVEN:

Now that you're done, the only things left to do are to cement the knot inside the knot cover and just the first one on the outside (just on the ends - NOT every single knot). Please see the "Toolbox" section for information about cements.

Close the clamshell while it's still wet, so everything fuses together.
Carefully trim off the excess thread when dry.

Using a plier, attach your clasp to the loop on the knot cover and close the loop.

COLOR PHOTO INDEX

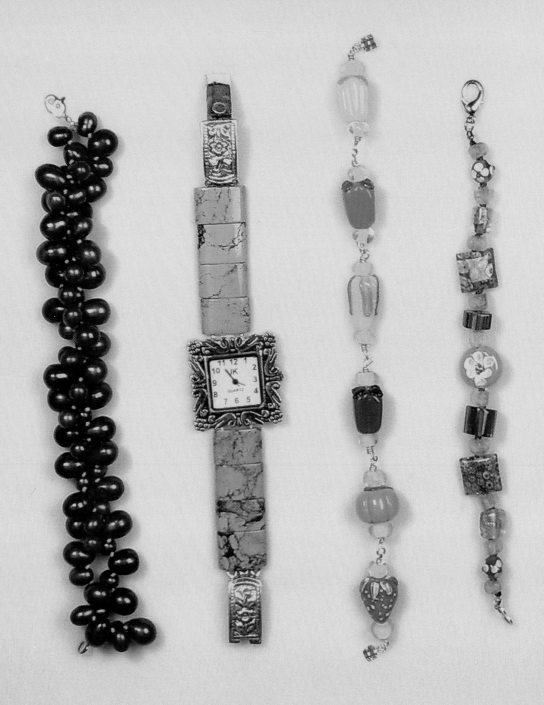

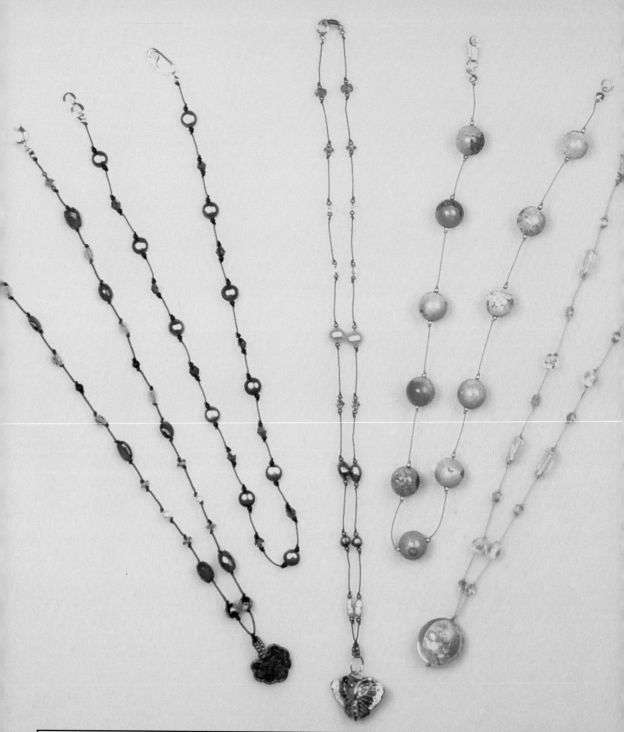

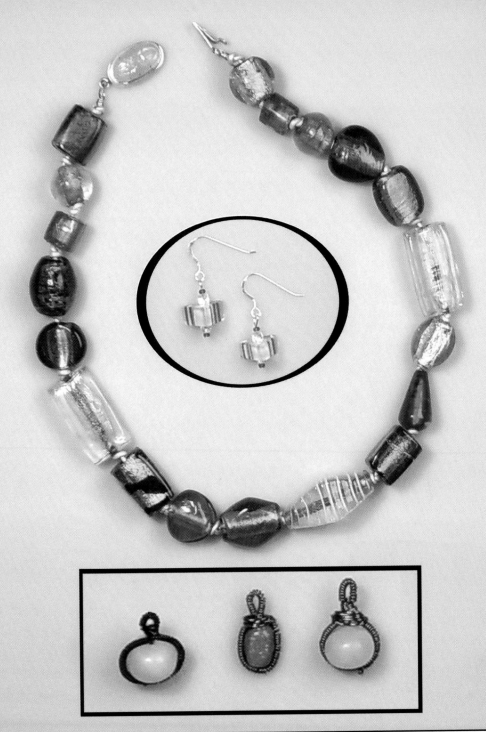

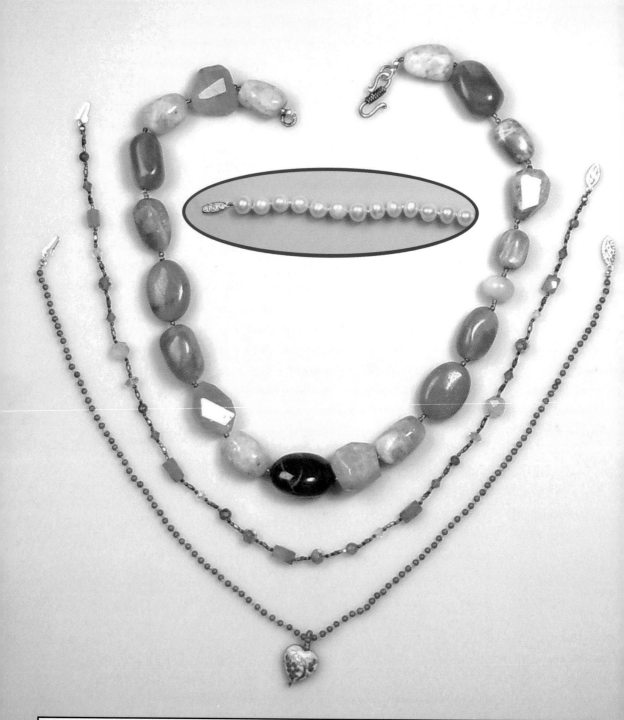

CLASSIC PEARL NECKLACE

When you want to get dressed up and feel elegant, nothing completes the look better than a nice strand of pearls. This elegant strand uses fresh water pearls. The variety of pearls at affordable prices is always growing. You can use this same technique and the look will vary just by the pearls you choose.

Really good pearl necklaces usually have bullion on the ends. The method for starting a necklace with bullion is on page 6. Start your necklace as shown, and continue on with the knotting techniques shown on page 8. By the way, most fresh water pearls are drilled to take either size 4 or 5 of silk thread.

This method will work with any beads, not just pearls.

YOU WILL NEED:
- A strand of pearls and a nice clasp
- Two 1/2" pieces of bullion
- Scotch tape
- A small card (appx. 2x2")
- Silk thread in appx. size 4 or 5
- Sharp jeweler's tweezers
- Jeweler's cement
- A small ziplock bag (appx. 3x4")

STEP ONE:
After you are done knotting between all of your beads except one, add the second piece of bullion - Figure (A).

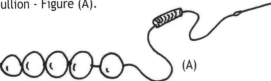

Thread on the clasp and bend the bullion in half - Figure (B)

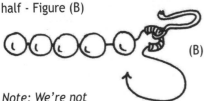

Note: We're not knotting between the last two beads just yet. We need to make a knot there later, and we don't want the knot to be too big.

STEP TWO:
Make a knot in the thread where the bullion comes back together and bring your needle back through the last bead as shown in Figure (C).
Make an overhand knot between the last two beads - Figure (D)
Cement as shown in Figure (E) and trim the excess thread when dry.

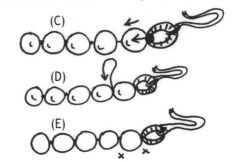

JUICY COLORS NECKLACE

There was a time when knotting between seedbeads was considered an obsessive-compulsive disorder. Happily, those days are over and the stigma is gone. Knotting between seedbeads is labor intensive (I won't lie to you), but worth it when you see the finished product.

There's a boutique here in Los Angeles that sells knotted seedbead seedbead necklaces for $300. Not bad, considering there's probably $2 worth of beads there. So, if you're in the mood for a new look, this fun necklace is the one! The rich berry colors offer unsual combinations; and truth-be-told, this was just odds and ends left over from other projects. Don't be afraid to play with color. One of my other books, *The Best Little Beading Book*, has a section devoted to this.

YOU WILL NEED:

- Size 11 seedbeads in bronze
- Size 11 three-cut seedbeads in bronze
- A mixture of beads in berry colors
- A clasp and two knot covers (I used clamshells)
- Orange silk thread in size 4 • Jeweler's tweezers
- A 3x4" ziplock bag and a small card
- Scotch tape • Jeweler's cement

Using the techniques shown on page 7, start with your knot covers and string your beads. I used orange thread, because I wanted the contrast of the cool berry colors with the warm orange. There is no real order to the beads (randomness can be fun), but everytime you add a bead, make sure you put a seedbead on either side. Why? Because we are knotting between the seedbeads, not at the bead itself. This adds a little more shine to the design. The 3-cut seedbeads are treated like a larger bead, with the smaller seedbeads on either side. One possible order of beads would go like this: seedbead (sb)/berry quartz/sb, sb/3-cut/sb, sb/crystal/sb, sb/3-cut/sb, etc. Always in groups of three. If you have a bead board, play with the layout until you are satisfied. Just remember to add the bronze seedbeads to give it an "antique" look. When you're working with seedbeads for your jewelry, there are 4 colors you should always have in your collection. Bronze is #1 - even the junkiest beads look better with bronze mixed in. Next, I like black seedbeads, because they add a richness. I also like pewter (deep silvertone), and an off-white pearl. I favor the deeper metal colors (bronze vs. gold and pewter vs. silver) because the deeper colors look more classic, and some of the lighter tones look cheap.

To finish, add your last knot cover in THE OPPOSITE DIRECTION so the hook faces outward. The knot covers should look like they are back-to-back on the necklace. Cement, close the clamshell, let dry, trim your thread, and add your clasp.

(example for positioning of clamshells)

RED CORAL LOCKET NECKLACE

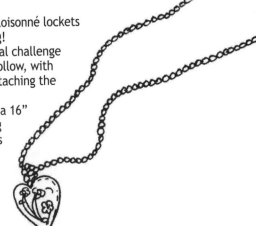

This simple necklace was inspired by a bag of antique cloisonné lockets I found at a flea market. I paid about $5 for the whole bag!

I like the way the locket has such rich colors: but the real challenge came when I needed to string it onto the necklace. It is hollow, with a hole that runs vertical (like a bead). This solution for attaching the necklace works with anything that is vertically drilled.

When you knot between your beads, it adds length. So, a 16" strand of a 4mm bead will end up being about 22-24" long (each knot adds about 1/8" in length, so there are 8 knots to the inch). If you figure there are about 64 beads on a strand, then you're making 8" in knots. Keep this in mind when you pre-string; you will need to adjust the length.

YOU WILL NEED:

- One strand of 4mm red coral beads
- A locket or pendant
- Jeweler's tweezers
- Scotch tape
- Silk thread (the red coral took size 4) - I used bright yellow to match the locket
- A clasp and two knot covers (I used clamshells)
- A 3x4" ziplock bag and a small card
- Jeweler's cement

Using the techniques shown on page 7, start with your knot covers and string your beads. Pre-thread your beads on (adjust the length as desired) - don't worry about adding the locket just yet. Save 5 red coral beads to use as a bail. Go ahead and knot the necklace. Add your second knot cover and finish as shown on page 18.

EASY STEPS:

To make a bail for your locket, bring your needle with thread up through the hole in the bottom of the locket - Figure (A) Secure the tail piece with tape, and make a knot at the top - (B) Add your beads, knotting between each - (C) Bring the beads around in a loop, and knot. Bring your needle down through the locket again - (D) Knot and cement the threads where they come together at the bottom of the locket - (E) Feed the necklace through the loop - (F). The locket will move freely on the necklace, not in a fixed position.

MIXED STONE NECKLACE

Each project in this book offers a new challenge. This one answers the age-old question, "What do you do when your beads have holes that are different sizes, and I can't find one thread to work with everything?"

Seedbeads are the great equalizier! Even with beads as large as these, you can put a seedbead on either side of each large bead, and calibrate your thread to match your seedbeads.

But, you ask, what if the hole is so big it swallows up the seedbead? Well, just put 2, or 3, or however many it takes to achieve the same look the other beads have. Those extra beads will be hidden in the large bead, and no one will ever know how many it took to make everything uniform. Everything is being locked into place with a knot, so you don't have to worry about slipping beads.

I use size 11 seedbeads for most of my work - they're easy to work with and a good standard to have on hand. This large stone necklace is very popular, and it also came from odds and ends of leftovers. You and your beading buddies can share several strands to mix and match colors.

YOU WILL NEED:

- A mixture of very large stones
- #11 Seedbeads (bronze)
- A clasp and two knot covers (I used clamshells)
- Jeweler's tweezers
- A 5x7" ziplock bag and a card (the larger beads require a larger bag)
- Scotch tape
- Jeweler's cement
- Silk thread (these seedbeads took size 4)

This works up using the same techniques as shown before. The thing you want to adjust as you go is how many seedbeads you may need to use. In a perfect world, it's just one on either side of each bead, but realistically speaking, you should fit the beads with the seedbeads and adjust as needed. Knot as before (I know the larger bag seems a little more clumsy to work with - I like to work with the smallest bag possible, but it's really the size of the beads that determine the bag - they need to fit into the bag comfortably, so it's easier for you to work with them). When done, cement and add your clasp.

KNOTTED LEATHER & GLASS NECKLACE

What do you do if the large beads you want to use have holes that are so big, that seedbeads can't fix the problem? Large seedbeads would just look awkward in the design; small ones disappear. Well, now it's time to look at our stringing medium. The same technique for knotting will work, but maybe it's time to graduate to something heavier - like cording or leather.

Now, I know your next question - do they make knot covers for leather? Nope - they do make something called "crimp keys" - sort of a tube with a loop attached, that you use with a plier - but sometimes, even the crimp keys aren't big enough.

So, only one thing to do - we have to make our own end findings.

YOU WILL NEED:

- Appx. 20 large beads (the length is up to you
- Leather cording (1 yard)
- #24 gauge wire
- A 5x7" ziplock bag and a card
- A clasp
- Scotch tape
- Jeweler's tweezers
- Jeweler's cement
- Round nose pliers

STEP ONE:
Make a knot about 2 inches from the end of the leather. Go ahead and pre-thread the beads on, then knot. Make a knot at the end of the necklace, and trim off all but 2 inches - Figure (A)

STEP TWO:
Take a 3" piece of wire and bend it as shown in Figure (B), using your pliers. Lay the wire alongside the leather, and start wrapping the long end in a coiling motion around the leather

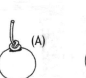 (A) 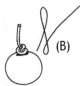 (B) (C) (D)

and the base of the wire (C). Wrap tightly, as this needs to hold the leather in place. Cement the end, and trim the excess wire and leather when dry - Figure (D).

SUMMER DAY BRACELET

What could be more refreshing than a pretty new bracelet for a summer's day? This glass bracelet was knotted on emerald green silk thread. Using green took some of the "sweetness" out of the blues.

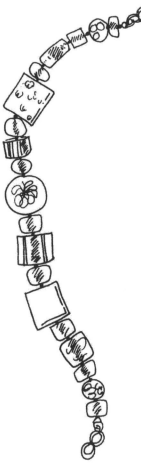

What makes this bracelet unusual is that all of the glass beads have very large holes. These were left over from other projects, and ended up together because they have the same look. Don't let your beads with odd holes scare you off from using them - there's always a solution.

I used size 10 silk thread on a card, which is very thick, and it made a larger knot that adds to the design.

Also, instead of using an ordinary jumpring with my clasp, I used something called a "Figure 8". It has a nicer look, and can also be used to add charms.

Experiment with your findings, so that your pieces won't all look the same. Like everything else, we get into a rut and end up using the same materials in everything we do. Part of that is thriftiness: if you bought a large bag of 144 things, you probably want to use them all up before you try something else. Swap with your bead buddies, so you can all have a variety of findings without a huge investment.

Also, as we mentioned earlier: bracelets require special clasps that can be manipulated with one hand. Avoid toggles, they come open - lobsters or magnetic clasps are the best.

YOU WILL NEED:

- Ten 5mm frosted glass turquoise colored beads
- Two 6mm flowered glass beads
- Two furnace glass beads
- Two square glass beads about 3/4" square
- One large flowered glass bead
- Two translucent glass beads
- A clasp (figure 8 or jumpring will do) and two knot covers
- Jeweler's tweezers
- A 3x4" ziplock bag and a card
- Scotch tape
- Silk thread (to fit the holes in the beads)
- Jeweler's cement

This is a very quick project. Knot as shown in the section on knotting, and secure and cement the ends.

CRANBERRY HOLIDAY BRACELET

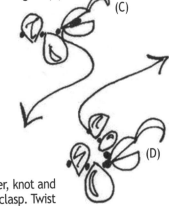

The pearl industry has really exploded with lots of beautiful new types of pearls. These side-drilled cranberry pearls nest together much differently than straight traditional pearls do. That's why this double-strand twisted bracelelt has such a festive look. We will actually use just two clam knot covers with this bracelet, as it is strung in one long continuous way.

YOU WILL NEED:

- One 16" strand of pearls
- Silk thread in size 4 or 5
- Two clamshell knot covers
- A clasp (suitable for bracelet)
- Jeweler's tweezers • Jeweler's cement
- Scotch tape • A 3x4" ziplock bag and a card

EASY STEPS:

Divide your strand of pearls in half. Prepare your strand by adding your first knot cover as previously shown. Pre-thread 8 inches (1/2 of the strand) and knot (DO NOT string the second half of the pearls just yet). When you get to the end of the first 8" length, bring your needle into the knot cover as if you were finishing the bracelet - Figure (A)

Make a knot and bring the needle back through the knot cover - Figure (B)

Make a knot as if you were starting a new bracelet (this is your second strand - Figure (C). Scotch tape the first strand out of the way at this point, so it won't get caught in your work.

(A)

(B)

(C)

Add the rest of your beads and continue knotting until you've used all your beads - Figure (D).

(D)

Bring the thread into the first knot cover, knot and cement as usual. Trim and attach your clasp. Twist the strands of the bracelet to get the full effect.

PEARL & CRYSTAL NECKLACE

A popular variation of the standard knotted necklace is one where the thread shows. Sometimes called a "tin cup necklace", this uses very few beads and makes a delicate style that most people like to wear. It costs less than $5 to make (in most cases), and if you're selling your designs, you will make a nice profit with this.

The difference between this and a solidly knotted necklace is the way that the beads are separated by visible thread. The beads are locked into place with a knot (the same one we've been making), and you will need measure the distance between the segments so they will be spaced uniformly.

Generally, it's best to use delicate beads with this style: pearls and crystal are very popular. Don't use white thread, because it stains easily.

YOU WILL NEED:

- A mixture of crystals, pearls and frosted blue seedbeads
- A clasp and two knot covers (clamshells or bead cups)
- Silk thread (these seedbeads took size 3)
- Jeweler's tweezers
- Scotch tape
- A 3x4" ziplock bag and a card
- Jeweler's cement

EASY STEPS:

Add your knot cover and beads to the thread. Make the first knot in the knot cover, and a knot just outside of it. Make 2 marks on a small card (they should be no more than 1" apart - this necklace is 1/2" between segments - my default distance). You will be able to move this card along the necklace as your work so it's where you need to measure.

To get the distance, put your tweezer on the first mark (A) and complete the knot. Lay your thread alongside the marks, and complete the second knot on (B). Remember to make the knot both before and

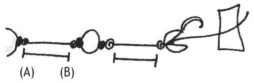

(A) (B)

after each beaded segment, or the beads will not be locked in place, and they will move. The spacing will determine the number of beads you use. The further apart, the fewer beads and the longer the length. For the best look, use an odd number of segments, so one will hang in the middle and look more balanced. This should be a symmetrical necklace, so try to make each side match. The sequence of the beads are alternating pearls and crystal,

TURQUOISE NECKLACE

This is a variation of the previous technique, but this time we're using a very simple design. These large turquoise beads paired with sterling silver (not seedbeads this time) make the look totally different.

Because sterling silver beads have such large holes, we're using a different type of cording for this. This cord is called "Conso", and it is used mainly for upholstery. It is nice and strong, and the twist of it is different than silk, and adds a little rougher texture to the project.

NOTE: I used 11 of the turquoise beads and 22 of the sterling silver, and my spaces were appx. 1" apart, and ended up with a 16" necklace.

YOU WILL NEED:

- One 16" strand of 10mm turquoise beads
- Twenty-two 2mm sterling silver beads
 (this will differ if you change the
 spaces between or want a longer necklace.
- About 3 feet of Conso (natural color)
- Two clamshell knot covers
- A sterling lobster clasp with jumpring or figure 8
- Jeweler's tweezers
- Jeweler's cement
- Scotch tape
- A 3x4" ziplock bag and a card

EASY STEPS:

Using the techniques shown previously, mark your distances between segments and add your beads. You'll find working with conso is different than silk - the twist is different, and it just doesn't feel the same in your hands. It's a little stiffer and takes getting used to, but it has wonderful uses and gives the necklace a "rougher" look, which shows off the matrix in the turquoise.
Complete and cement as usual, add your clasp.

CITRINE GLASS NECKLACE

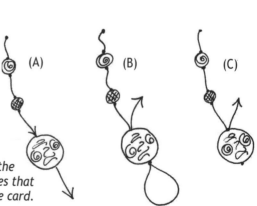

Beyond just the garden-variety tin-cup necklaces, it gets more fun when you add a pendant. There are different ways to add them. This necklace mixes Czech crystal and lamp beads with Chinese dichroic glass. It's okay to mix anything you like that you feel works together.

YOU WILL NEED:

- A large dichroic [flat/round] bead to act as a pendant
- Four Czech 6mm lamp beads
- Four dichroic tube beads • Ten 5mm Czech firepolished crystal
- A clasp and two knot covers (clamshells or bead cups)
- Jeweler's tweezers • A 3x4" ziplock bag and a card
- Scotch tape • Jeweler's cement
- Silk thread (size 4)

STEP ONE:
Prepare your knot covers and add half of the beads. Remember, this is a symmetrical design; divide up the beads so you don't use all of one kind on one side. Marking off your spaces (this one is 1/2" between segments) knot the first half of the necklace, up to the point where you want to add the pendant. The order of the beads are (commas separate segments): knot cover, crystal, dichroic tube, crystal, lamp bead, crystal, dichroic tube, crystal, lamp bead, crystal, pendant.

STEP TWO:
To add the pendant: String on the large center bead, but don't make a knot at the top (you don't want a great big knot there, so just hold the bead in position - Figure (A)
Make a knot below the pendant - Figure (B)
Bring the needle back up through the pendant and make a knot on top of it. Continue finishing the necklace (string the beads in the reverse order than the first side) - Figure (C).
Complete and cement the knots in the knot covers (as usual) and the knot at the top and bottom of the pendant. Trim all threads carefully when dry.

(A) (B) (C)

NOTE: You will be able to build the second side of the necklace by measuring off the first side. This insures that both sides match, and saves you having to move the card.

BUTTERFLY NECKLACE

This lovely necklace has a pendant also, but it is attached differently than the previous project. In this one, we make a ring of seedbeads to attach to the ring at the top of the pendant. With this method, you can use charms and other mementos to make a very personal necklace. By the way, the beads listed below are just a suggestion. As you can see, you just need 2 of each, so you can adapt the design to what is left over in your bead collection.

YOU WILL NEED:

- Two blue rice pearls
- Two 4mm bronze pearls
- Two peacock pearls
- Two blue topaz rondells (4mm)
- Two green quartz rondells
- A gold filled lobster clasp with jumpring or figure 8
- Silk thread in emerald green in size 4
- Jeweler's tweezers
- Scotch tape

- Two 3mm crystal bicones - green
- Two 3mm crystal bicones - clear
- Two peach colored pearls
- Two brown rondells
- Fifty-one bronze #11 seedbeads

- Jeweler's cement
- A 3x4" ziplock bag and a card

NOTE: My spaces were 3/4" apart (I like the emerald thread and wanted it to show), and this makes a 19" necklace.

STEP ONE:

String 1/2 of your beads on your prepared thread (after you've added the knot cover). Remember to divide the beads in two, so that both sides have the same beads to create a symmetrical necklace. Knot half of the necklace until the point where you add the pendant. The bead sequence is (commas separate each segment): seedbead (sb)/green quartz rondell/sb, sb/brown rondell/sb, sb/blue topaz/sb, sb/crystal/sb, sb/peach pearl/sb, sb/green bicone/sb, sb/peacock pearl/sb, sb/bronze pearl/sb, sb/rice pearl/sb, pendant.

STEP TWO:

To add the pendant, make a knot at the point where the next segment should be and add 6 seedbeads, then make another knot - Figure (A). Add the pendant - Figure (B). Pull up the two ends together, and make a knot at the ends of the seedbeads to make a loop - Figure (C). Continue on and finish the necklace by adding the beads in the reverse order to match the first side. Cement and add your clasp.

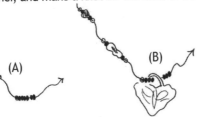

(A) (B) (C)

CARNELIAN GOOD LUCK NECKLACE

This is a great necklace when you want a more elegant look. The rich fall colors seem a little more stylish than pastels, and this is a great necklace for evening. This mix of carnelian, citrine, pearls and cloisonné combine beautifully with the bronze of the seedbeads and the pendant. It's best to work this with the small beads suggested, to keep the look stylish. It would give a very different effect with larger beads.

 This pendant is considered a good luck charm.

YOU WILL NEED:

- Two 6mm cloisonné beads • Four citrine rondells
- Four faceted barrel-shaped carnelian beads
- Six 4mm citrine beads
- Two 4mm citrine-colored bicones • Two 4mm white pearls
- Two 3mm black onyx • Four lentil shaped garnets
- Fourteen bronze #11 seedbeads
- A gold filled lobster clasp with jumpring or figure 8
- Silk thread in black in size 5
- Jeweler's tweezers • Jeweler's cement
- Scotch tape • A 3x4" ziplock bag and a card

NOTE: When I was designing this necklace, I decided that using bronze seadbeads with each segment gave it a look I didn't like. So, the bronze seedbeads are just next to the bicone crystals up near the clasp, not with every segment. This keeps the emphasis with the stones, and helps the composition. Sometimes, just throwing in seedbeads at one part of the necklace looks a little odd. It's a good idea to "pepper" the piece with some, just so it looks like it was your plan to use the seedbeads at the pendant, not an afterthought.

EASY STEPS:
This is very similiar to the previous pattern, and the sequence of the beads is as follows (the segments are separated by commas):
knot cover #1, seedbead/bicone/seedbead, carnelian, 4mm citrine, garnet, 4mm citrine, black onyx, 4mm citrine, garnet, citrine rondell, pearl, citrine rondell, carnelian, cloisonné, 10 seedbeads, add pendant and secure, and continue up the second side of the necklace to match the first (after the pendant, the beads go on in reverse order). Secure, cement, add your clasp, and trim when dry.

THE TOP TWELVE THINGS THAT CAN GO WRONG WITH KNOTTING

1. HELP! MY NECKLACE IS KNOTTED TOO TIGHTLY!

All you need to do is GENTLY stretch it in a circular motion. Most threads have a twist, and this will release the tension so it will hang nicer. DO NOT pre-stretch your silk thread - it will kill the life and bounce, and will look like somebody's stretched out elastic waistband! You are better off working tightly: everything tends to loosen up with wear.

2. HELP! MY NECKLACE IS KNOTTED TOO LOOSELY!

Not to worry! Take a number 12 English beading needle and nymo (very thin) nylon thread in a size 0. Stitch into the end knot (the one outside the knot cover, assuming you've already closed and cemented the knot cover. If not, then secure it to the one inside the knot cover). Run the thread through the beads, knots and all.

Carefully, pull the nymo thread tight, like a drawstring. You will see the necklace "firm up" before your eyes (sort of like a face-lift for your necklace). While it's pulled tight, carefully stitch into the knot at the other end of the necklace, cement both ends of the nymo, and carefully trim.

NOTE: This works best when you match the color of the nymo to the thread.

3. HELP! MY CLAMSHELL KNOT COVER BROKE!

Take the two halves and fit them together (like a sandwich) where they belong. Use an industrial cement like 527 or E6000, and cement it all together - think of putting mayonnaise on your sandwich - enough to bond the two halves of the clamshell to the knot. Let it dry, and it should stay together.

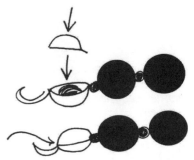

NOTE: This is not the same cement you've been using for your knots. This is a more heavy-duty cement. Please see the Toolbox section in the back for more info on recommended supplies.

THE TOP TWELVE THINGS THAT CAN GO WRONG WITH KNOTTING

4. HELP! I DROPPED MY NECKLACE AND A BEAD JUST BROKE! DO I HAVE TO RESTRING IT?

Nope, just cement the two halves together as you did for the clamshell in Number 3.

5. HELP! MY KNOT COVER JUST SLIPPED RIGHT OFF THE NECKLACE! DO I HAVE TO RE-DO EVERYTHING?

No. Just thread an English beading needle (#10 or #12 is fine), and you'll be able to stitch a new knot cover back on (like mending).

This will work with both clamshells and bead cups, although it will be easier to hide the repair in a clamshell - Figure (A)

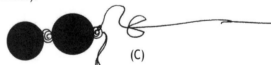

You'll probably need to use a new knot cover if you've already closed and cemented the one that came off (they tend to warp when you re-open them).

If possible, you can stitch into the end of the thread so it can be dragged into the clamshell and used in your repair knot - Figure (B).

Knot repeatedly in the clamshell and cement well.

If it's not possible to bring that little piece of thread into the knot cover, stitch securely into the last knot in the thread (yet another good reason for knotting between beads).

Bring the English beading needle through the knot cover. You will need to knot several times and cement securely. When it doubt, cement all of the new knots. Trim when dry.

NOTE: *This happens quite often when the thread is too thin and the knot just slips out of the knot cover because there is nothing inside to hold it in place. You can always use a #11 seedbead hidden in the clamshell and knot around it to secure the ends. Of course, you would cement it before you close the clamshell.*

6. HELP! THE ENDS CAME OFF MY OLD NECKLACE!

Repair as shown above in Number 5.

THE TOP TWELVE THINGS THAT CAN GO WRONG WITH KNOTTING

7. HELP! I PRE-STRUNG MY BEADS, BUT I PUT TOO MANY SEEDBEADS ON. DO I HAVE TO PULL EVERYTHING OFF THE THREAD AND RE-STRING IT ALL?

No, just very carefully take your plier and break the seedbead. It's made of glass, and just a little pressure will remove it from the thread. Be careful to cover your bead with your hand when you do this, so no little pieces of glass fly up. Also, take care not to cut the thread.

8. HELP! MY CAT JUST BROKE MY THREAD! DO I NEED TO START ALL OVER AGAIN?

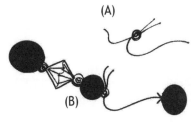

(A)

(B)

Join the broken end to a new end with an overhand knot. This works better than most knots, because the more you pull on it, the tighter it gets. It's very hard to pull this out. - Figure (A)

A little big of cement on the knot will help it stay together. As for the placement of the knot, put it as close as possible to the last bead strung on the strand. This will make it less obvious. If possible, you can hide the knot inside a bead. (Figure (B). Position the knot where desired, then continue on knotting. After the cement is dry, trim all ends.

NOTE: This works best when you match the color of the nymo to the thread.

9. HELP! I FORGOT TO KNOT BETWEEN 2 BEADS! DO I NEED TO UNDO ALL MY KNOTS?

No, you can tie on a separate piece of thread. Be careful to make a knot that isn't much bigger than the others on the strand (use the same weight of thread). Cement, let dry, and trim.

THE TOP TWELVE THINGS THAT CAN GO WRONG WITH KNOTTING

10. HELP! MY KNOT IS IN THE WRONG PLACE! I NEED TO MOVE/OPEN IT! WHAT DO I DO?

This is one of the worst things that can happen when you're knotting. That's why I suggest the ziplock bags - to minimize this sort of thing. But, occasionally, rogue knots do happen! It is much easier to manipulate a thicker thread than a thinner one. So, if you're just starting to knot, practice with size 5 on up with the thread until you get the feel of it. When you need to move a knot, there is a chance of doing damage to the thread, so caution is advised. Carefully work a pin into the center of the knot and wiggle it around. Then, place the points of the CLOSED tweezer into the knot, and open the tweezer. This will pop the knot open. Loosen it and undo it, then start again, being careful of the placement. If it's still not in the right place, loosen it again, and go have a cup of tea. When you get back, the thread will have smoothed out enough to let you put the knot in the right spot.

11. HELP! THE BEADS ON MY TIN CUP NECKLACE AREN'T STAYING IN PLACE! DO I NEED TO RE-DO IT?

No, just position the beads where you want them and squirt a little cement into the hole. This is a nice little "cheat" when the thread wasn't thick enough to make a knot that held the beads in position. Don't be tempted to "check it" until it's dry, because you don't want to have to re-cement and get a build-up that will make your necklace hang funny.

12. HELP! I'M GOING SHOPPING AND I DON'T KNOW WHICH SIZE THREADS TO BUY. DO I NEED TO BRING MY BEADS WITH ME?

No, there are several tips that help when building a collection of threads. Silk thread comes on cards in sizes 0 - 10; or on spools in sizes A - FFFF. "F" weight silk is approximately equal to a #3 ; "FF" is equal to #4, etc.

Let price be your guide - generally, the more expensive the bead, the smaller the hole. So, if you paid $200 for that strand of rubies, you'll probably want a size 1 or 2. if you just paid $1 for garnets, you'll probably need size 5 or 6. Certain beads are notorious for their hole size: garnets always have large holes, hematite usually has very small. Most of what you need will be sizes 3, 4, and 5 of the silk thread. That will fit most standard beads.

WORKING WITH CABLE

Working with cable is very different than working with thread. For one thing, you really shouldn't knot it. You secure the ends with crimp beads. These are crushed with a special crimping plier, which flattens the beads. Crimp beads have little teeth inside them that bite into the plastic or vinyl coating on the cable, and that's what helps it hold it place. Crimp beads start out round - Figure (A).

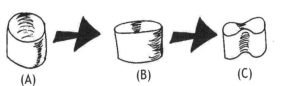

The outermost notch on the plier flattens them into an oval - Figure (B). The innermost notch has a little "tooth" in the middle, to make the crimp bead indent in the middle - Figure (C). This is so it will hug the cable securely - Figure (D).

Figure (E) shows the teeth of the crimping plier and the order of which notch should flatten the crimp first.

I know that there are some instructions that tell you to fold the crimp bead over, etc. but that just weakens it and it won't hold.

If you follow the crimping sequence shown here, your necklace should hold strongly.

(E)

Cable differs from wire because it is more flexible. It comes in different thicknesses, depending on how many little wires are contained into the cable. This is not to be confused with plain, old wire, which will not hold together if you try to use it for a necklace.

Some of the cable products you'll find are Softflex™, Tigertail and Acculon™.

Cable is great with very heavy or sharp beads, and for the athlete who wants to wear jewelry on their workout. Always test it before you recommend someone can swim in it. Water tends to mess up your metals and beads.

Cable generally comes on spools of 30, 100, or 1,000 ft. lengths. You can work directly from the spool, and eliminate a lot of waste - Figure (F). Or, if that's not possible, cut and length and put scotch tape on one end - Figure (G). Don't crimp anything until you are done and satisfied with your design. That gives you the ability to edit and make changes, without having to restring the whole thing. It also saves a crimp if you change your mind about the design.

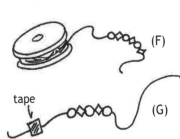

For every necklace you make using cable, you will need a clasp, two crimp beads (one for each end), cable of the appropriate thickness, scotch tape (recommended) and a crimping plier. Optional materials are discussed in the box at the bottom of the page. You'll find that the work goes very quickly with this technique. The first step is to string all of your beads in order, as discussed on the previous page. then, add your crimp bead, then your clasp - Figure (A). Bring the cable back through the crimp bead in the OPPOSITE direction from

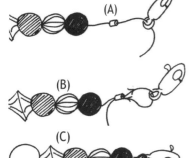

the first time - Figure (B). Draw it tightly together, but not too tightly. The problem is, if you make the little loop at the clasp too small and too tight, it puts too much stress on the very end of the cable and it breaks. If you've had a problem with your cables breaking, that is probably why. Leave a loop of cable that is approximately 1/4", the size of a jumpring - Figure (C).

You can feed the end of cable back through the beads if the holes in the beads let you. Be sure to trim away the excess cable, as it can be very sharp - Figure (D). When you complete the second side of the necklace,

adjust the tension so it doesn't hang too stiffly or too loosely - you don't want bare cable to show.

OTHER TOPICS OF INTEREST REGARDING CABLE:

- Crimp keys are crimp beads with a loop on the end. You feed the end of the cable into it and use pliers to crush it. I like to use a cement like E6000 or 527 to bond it into the crimp key so it won't pull out.
- If you don't like the way the bare cable looks, cut 1/2" piece of bullion and thread in on. This will cover it at the clasp and make it look fancier.
- Or, use a "crimp cover", which is specially designed to hide the crimp bead.
- Or, you can place your crimp bead inside a clamshell knot cover to hide it.
- Or, you can hide the crimp bead in a bead with a very large hole.
- No matter how you secure your cable, it is best to fold it over (as shown above). Being a bundle of wires, they can become unbundled and fray out. That is why it's a good idea to cement it if possible.

TURQUOISE WATCHBAND

I love beaded watchbands. They add so much to your look, and cost almost nothing to make. Lately, the availability of good quality watch faces has grown; it's very easy to find sterling at reasonable prices.

This project uses a sterling watch face and clasp, and turquoise double-drilled beads (this means there are two parallel holes in the same direction).

Each side of the watch band is one long continuous strand of cable. Because you subtract the length of the watch face and clasp from your measurements, each side only requires around 3 1/2" of beads. It is important to fit the wearer if possible, because wrist sizes can differ. For more information and other watch patterns, please see one of my other books, *The Beaded Watchband Book*.

YOU WILL NEED:

- One strand of double drilled turquoise beads
- One sterling silver bracelet clasp
- One sterling silver watch face
- Two sterling silver crimp keys
- Scotch tape
- A springbar removal tool (please see the Toolbox section)
- Cable in appx. .014 weight

STEP ONE:

Remove the springbars from the watchface (these connect the watch to the band). Be careful when you remove them that they don't go flying. This is why the tool is recommended.

Put the springbars in a safe place - they have a habit of getting lost easily.

Cut a length of cable about 10" long.

TURQUOISE WATCHBAND

STEP TWO:
Put a piece of tape on one end of the cable, and thread the beads on. As you work, you want to make sure that it is the same side of the double-drilled bead that is being threaded (these beads usually have a very distinct front and back).

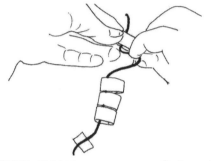

STEP THREE:
Thread all of the beads on and loop through your clasp. Again, make sure everything is facing the same direction.

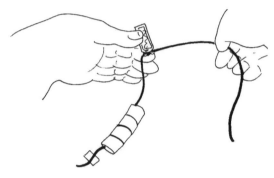

STEP FOUR:
Bring the cable back through the other set of holes in the beads and pull tightly.

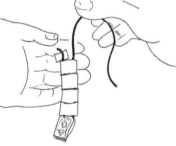

STEP FIVE:
Insert the end of the cable into the crimp key and use your pliers to crush the shaft of the crimp key. Trim the second end of cable and repeat.
Test it with your nail to see that it's tight and it holds. Repeat from step two for the second side of the band and complete the same way.

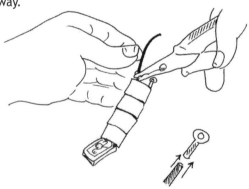

STEP SIX:
Insert the spring bar through the loops in the crimp keys and reattach to your watch.

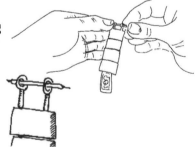

NOTE: Bend the watchband to make sure it's flexible. Sometimes, if you make it too tight when it's straightened out, it won't curve around your wrist the way it should when you try it on.

MULTI-STRAND TURQUOISE AND CORAL NECKLACE

One of my clients is an older Greek lady who had these beads from her childhood. They are not expensive beads, but they held sentimental value for her. She did not want to mix them with anything else - just these beads. She did allow me to add a clasp, though.

The large red coral beads were loose; she had several strands of the turquoise, and just odds and ends of everything else.

It was a challenge to use only what she had, but she was very pleased with the result.

This project is a way to make a multi-strand with odds and ends.

YOU WILL NEED:

- Nine larger coral beads with big holes
- An assortment of coordinating coral beads
- About three strands of turquoise beads
- A toggle clasp • Six crimp beads • Jump rings • Scotch tape
- Cable in appx. .014 weight (This is a 20" necklace, and it took about 3 yards).

NOTE: Sometimes you need a longer piece of cable to make your work easier. Having a three-strand that weaves back and forth takes more cable than a linear necklace would.

STEP ONE:

Divide the cable into three equal pieces about one yard long. Put a piece of tape on one end of each piece. You will be working all three strands at one time - it makes it a lot easier. If you can, work on a surface that you can tape the necklace to, like a plastic clipboard or placemat. Taping things down is like growing extra limbs! You will have a lot more control of your necklace as you work.

MULTI-STRAND TURQUOISE AND CORAL NECKLACE

STEP TWO:

Part of the challenge in working with a specific palate of beads is that you are rather limited by the sizes of them.

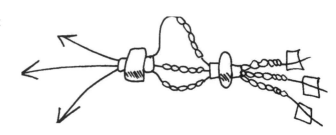

When you're making a necklace like this, and the beads are irregularly shaped, you are better off measuring your segments by the length, rather than the number of beads.

Because the three strands feed back and forth from the larger connecting bead to their individual segments, if you count the beads you may come up short. It's important that each segment be equal in length, or it will cause the necklace to bend or hang funny.

You will probably want to tape as you go, to keep things controllable.

STEP THREE:

To end this, you will crimp each strand into one common jump ring, and these will connect to the toggle.

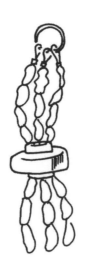

It will be more of a challenge to keep everything tight - you'll find it easier to complete both ends of strand #1, then on to strand #2, etc. Of course, there is no specific order for these strands - it's as you work each one in turn.

FURNACE GLASS EARRINGS

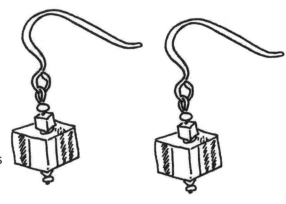

I was teaching a class at a gem show, and did a demonstration of how to make earrings, using furnace glass beads. I didn't know it, but the colors I chose were the same as the local team that was playing football that day. I had a line of people at my table who wanted to buy these earrings to support their team!

That's the thing about earrings - they are very quick to make, and everyone wears them, so you will always be able to meet the demands of your customers and have a large inventory for them to choose from. The truth is that earrings are the most cost-effective thing to make, both in time and materials.

NOTE: The earring findings shown here are for pierced, but you can get clip-ons and the technique is exactly the same. Also, the pattern calls for head pins. These are the basic pin with a head on the end (you could use an eye pin if you prefer - eye pins have a loop on the end). They are used for the vertical part of the earring. Also, sometimes the hole in the bead is too large, and you need a seedbead to stop the headpin from going right on through the bead.

YOU WILL NEED:

- Two large furnace glass beads
- Four 4mm Czech crystals
- Two head pins
- Four #11 seedbeads
- Two earwires

STEP ONE:
Thread your beads on in the right order. The head of the pin is at the bottom of the earring, so you will be working upward. A very popular design is to have the larger bead in the middle, so you would thread the beads in this order: seedbead, crystal, furnace glass, crystal, seedbead (this design has five beads per earring).

STEP TWO:
Measure about 1/2 inch from where the head pin comes out of the bead and trim, using your wire cutters.

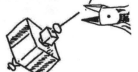

STEP THREE:
With your round nose plier, bend the head pin over from the base. This will help the curve be a little more symmetrical.

STEP FOUR:
Add your earwire.
It needs to be on the
headpin at this
point so that it
will be included
in the loop when
you close it.

STEP FIVE:
Using your round-nose plier,
form a loop over one side of
the plier. It's a rolling motion.
The size of your loop will be
determined by the part of the
plier you use.

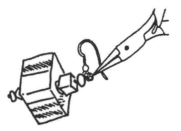

STEP SIX:
Finsih up by manipulating
the loop to be uniform.
Don't worry: sometimes
this doesn't come together
smoothly in one motion and
needs to be adjusted so that
the tip of the headpin goes
into the top of the bead.

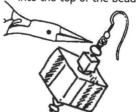

HOW TO COIL WIRE

A nice alternative to just making a simple loop is to coil wire. This takes a bit of practice, but the look is very popular. It takes two pliers to manipulate the wire (this will save your nails). One long piece of wire is bent over on itself and coiled around itself. You can connect segments and make an earring with movement. The next project takes this to the next level.

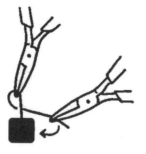
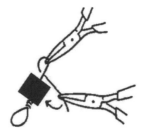
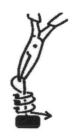

FRUITS'N'VEGGIES BRACELET

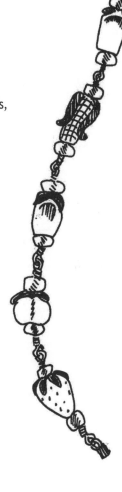

Using the coiling technique shown on page 40, you can take it a step further and make a bracelet or necklace of joined units.

For the Fruits'n'Veggies Bracelet, I picked glass beads from China that are in the right shapes. These beads have very large holes, and I wanted a different look than knotting or using cable. The gold-filled wire gives it a sense of style. I also used a magnetic clasp to make this easy to put on and take off.

YOU WILL NEED:

• 24 gauge gold-filled wire
• Twelve yellow glass beads
• Six beads in the shape of various fruits and vegetables
 (you can make a variation of this using Christmas beads, Halloween beads,
 angels, etc.)
• One magnetic clasp
• A round nose plier and a chain nose plier (please see the Toolbox section)

NOTE: The pattern calls for the yellow glass beads on either side of your larger bead.

EASY STEPS:

Working from the spool of wire eliminates a lot of waste. Add your first beads, then coil the end of wire. Give yourself a good inch or two to grip and manipulate with your plier. It's very difficult to get a good coil with a small piece of wire. After you've made your first coil, cut the wire off of the spool (leaving yourself a good two inches). Coil this end.

Now, you will join each segment as you coil the wire in place. If you find it's too hard to attach the segments to each other as you coil, than make each one separate and you can join them later with jumprings. Add your clasp, and you're ready to go!

MAKING A COILED BEZEL

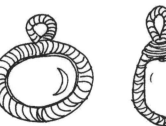

I love the variations of working with wire. I started playing with combining different gauges with each other.

And, what I found was that you could coil #24 gauge over a heavier #20 gauge and achieve some very unusual effects.

Here are wire-wrapped bezels for pendants, earrings, etc. These ornaments will dress up even the plainest necklace.

NOTE: For an unsual effect, try this with colored wire.

YOU WILL NEED:

• #24 gauge wire and #20 gauge wire (#20 is heavier than #24).
• A round nose plier and a chain nose plier (please see the Toolbox section)
• A bead to wrap

STEP ONE:

Working from the spools of wire, coil the #24 loosely around the #20. You want the coils touching, but you will need to pull the wire off and you don't want to wrap it too tightly, or it will be very difficult to take off. You'll

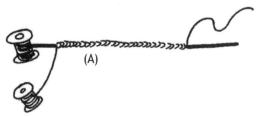

(A)

coil a piece that is long enough to completely fit around your bead's vertical measurement (circumference). You should practice your coiling before you attempt this, as it is intense to coil such a long piece of wire and have it look uniform - Figure (A).

When you have a length of coil that is long enough, carefully remove the #20 that is the core of the coil. The #20 can be re-wound around the spool and used for something else later.

You should have a length of #24 wire that holds its shape in a coil - Figure (B).

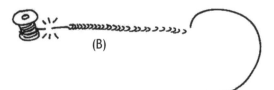

(B)

Leave a piece of straight wire about a foot long (don't trim too closely), and cut the spool of #24 off.

MAKING A COILED BEZEL

STEP TWO:
Take the end of the wire and feed it into the coil to make a closed loop. Use your plier to tighten it so it will fit snugly around the bead you've chosen.

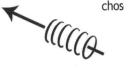
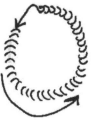

STEP THREE:
Feed the bead onto the long piece of wire left over.

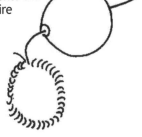

STEP FOUR:
Fit the bead into position in the center of the loop, and tighten as needed to create a snug bezel.

Bring the long piece of wire down into the bead and pull. Wrap the wire around the bottom coil (if you work tightly, this piece of wire will blend with the rest of the coil.

If the hole in the bead permits it, make the return trip back up through the bead. If not, tighten the loop around the coil and trim.

STEP FIVE:
Coil a separate piece of #24 wire around the #20 wire. This should be about One inch long. Pull it off the #20, cut to size, and thread onto the top piece of wire.

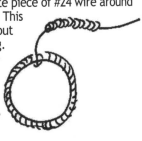

STEP SIX:
With your round nose pliers, make a loop with the coiled top section.

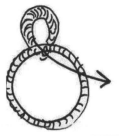

STEP SEVEN:
Bring the wire around to secure.

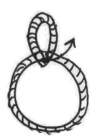

VARIATION:
If your wire end is long enough, continue coiling and make a collar for the bead.

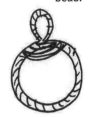

MULTI-STRAND CORAL & CABOCHON NECKLACE

At this point, this project will be a snap! This is a six-strand necklace, strung on cable, with a wire-wrapped bezel around the cabochon pendant.

YOU WILL NEED:

- A variety of beads (see below for pattern)
- A cabochon to wrap
- A toggle clasp (I used gold-filled)
- Twelve crimp beads
- #20 and #24 gold-filled wire
- A cabochon to wrap (try to pick up the colors of your beads)
- A round nose plier and a chain nose plier
- Jump rings
- Two three-hole necklace bars
- Scotch tape

STEP ONE:

The first part of this necklace is to string each of the six strands. This design is as follows:

Strand #1: Small red coral branches
Strand #2: Alternating red coral rondells and bronze square 2mm beads
Strand #3: Alternating amber and bronze square 2mm beads
Strand #4: Alternating strawberry quartz lentil shape and 5mm rounds.
Strand #5: Alternating lentil shaped peach colored pearls and carnelian
Strand #6: Alternating red seedbeads (#11) and faceted agate.

String each of these separately and hold with tape until you are happy with the way it drapes. You may need to adjust the length to get the perfect twist.

MULTI-STRAND CORAL & CABOCHON NECKLACE

STEP TWO:
The necklace bars give the six strands structure - Figure (A).
Two strands will terminate in a jumpring so you will have a total of three jumprings - Figure (B).
Each of the three jumprings will connect to the necklace bar - Figure (C).
The necklace bars connect to the toggles with a jumpring - Figure (D).

(A) (B) (C) (D)

Assemble the second side and twist for a torsade effect.

NOTE: When you're making the cabochon bezeled pendant, you want to leave a piece of wire at the end that is long enough to fit around all six strands like a pearl enhancer.

STEP THREE:
To make the cabochon bezel, you will use the techniques shown on page 42. But, because the cabochon is not drilled, you will adapt the way it fits with the wire. You won't be able to bring the wire throught the bead to stabilize it, so instead, you'll do the following:
With a needle file, make a groove on the side of the cabochon - Figure (E).
Fit the wire bezel into the groove - Figure (F).
Bring the ends of the wire up through a bead, and twist the wire to tighten - Figure (G). At this point, you may want to cement the bezel to the cabochon with 527 or E6000 cement.
Make two separate pieces of coil and slide them on the long ends of wire - Figure (H).
Bend the long pieces over and coil to secure them - Figure (I). Remember to make this long enough for your necklace to fit into. Feed the finished necklace into the pendant.

(E)

(F)

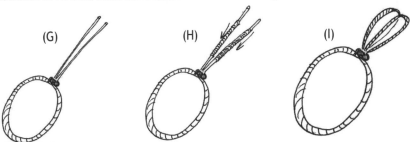

(G) (H) (I)

20 THINGS MAMA NEVER TOLD YOU ABOUT MAKING JEWELRY

1. DO I ALWAYS NEED A NEEDLE?

When your stringing medium is stiff like cable or conso, you won't need one.

2. WHAT IF MY NEEDLE BREAKS AND ADDING A NEW ONE MAKES IT TOO THICK TO FIT THROUGH THE BEADS?

Try putting a little cement on the end of the thread to stiffen it and become a self needle.

3. HOW CAN I ADD LENGTH TO AN EXISTING NECKLACE?

Instead of a clasp, attach the knot covers to a length of chain. If the links are big enough and you have a hook-and-eye clasp, you can make this adjustable lengths.

4. CAN I USE THE COILING TECHNIQUE SHOWN FOR ANYTHING ELSE?

Use the same technique to make coiled wire beads to add to your necklaces.

5. HOW DO I MAKE HOLES IN BEADS LARGER?

You can use a little "Needle reamer" for pearls - it's like a mini-file. There's also larger electric drills and hand-drills. Some stones require that you drill under water so they won't crack.

6 HOW CAN I SMOOTH ROUGH STONES?

If they're just a little rough, use a file. If you want to increase the overall smoothness, use a rock tumbler.

7. MY PENDANT BROKE! WHAT CAN I DO?

Either cement the break, or wirewrap over the broken part and no one will know.

8. MY JUMPRINGS NEVER KEEP THEIR SHAPE! WHY IS THIS?

Don't pull them out to open them; swivel them sideways and that will keep the circle intact.

20 THINGS MAMA NEVER TOLD YOU ABOUT MAKING JEWELRY

9. WHAT IS THE BEST CEMENT FOR RHINESTONES?

The Jeweler's Cement won't eat up the foil backing.

10. I MADE MY OWN EARWIRES AND THE ENDS ARE TOO ROUGH!

File them with a needle file or emery board .

11. HOW CAN I MAKE MY OWN NEEDLE?

Take a piece of #28 gauge wire and twist it to form an eye in the needle, and use this.

12. HOW DO I ADD A BEAD THAT'S SIDE DRILLED?

Make a bail with wire feeding through it sideways. Pull up the sides and round one side of the wire and wrap with the other. Coil one end around the other.

13. HOW WILL I KNOW THE DIFFERENCES IN THE SIZES OF WIRE?

It's a backwards system when it comes to numbering wire - the higher the number, the thinner the wire. So, size #18 is thicker than #20, which is thicker than #22, etc. Most earwires and headpins are #22, but sometimes pearls need a size #24.

14. HOW DO I SOLDER?

I like to solder my knot covers closed or do repairs.

Use a UL approved soldering wand. It plugs in and heats up to be very hot. You should use tools to grip what you solder, because they will become hot when the wand touches them and you can get burned.

Find one with a nice fine tip, to give you more control.

You need to buy special solder - this looks like wire, but it dissolves with the intense heat and fuses into the gap. Hardware stores carry this. You want one with flux - it makes it easier. For 14k gold, you need real gold solder so it will bond; I use sterling silver solder the most, because I found it bonds to white gold and looks fine at a fraction of the cost.

Touch the soldering iron to the metal you want to solder. This is a referred heat, meaning the metal jumpring, etc. will pick up the heat. Touch the solder to the heated metal, and it will fuse where you want it to. Don't touch the soldering iron to the solder, because that will just get the tip of the iron all gunked up. Use the solder sparingly.

Let cool before you touch or wear.

20 THINGS MAMA NEVER TOLD YOU ABOUT MAKING JEWELRY

15. HELP! I MADE A HORRIBLE MESS WITH THE SOLDER! WHAT CAN I DO?

You can buy a Solder Removal Wand, which looks like a soldering wand but has a bulb attached. Heat it up and suction off the unwanted solder.

16. IT'S A REALLY HOT DAY AND I DON'T WANT TO SOLDER. ANYTHING ELSE I CAN DO?

Make a little puddle of 527 or E6000. Dip the area you want to solder and let it dry. I use this on non-precious metal jumprings to seal them shut. I just dip the end with the open gap, and a little bubble of cement is formed.

17. HOW DO I MAKE MY OWN JUMPRINGS?

Wrap the #22 gauge wire around one side of your round-nose plier - Figure (A)

Take the plier out of the graduated coil - Figure (B)

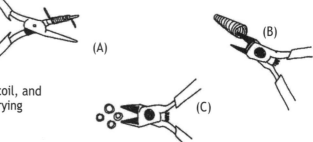

Insert your cutter into one side of the coil, and cut. You'll have lots of jumprings of varying sizes - Figure (C)

18. MY THREAD IS THE WRONG COLOR! WHAT CAN I DO?

Use a permanent marker and very carefully color it. Let it dry completely before you use it. This works best on nymo. Silk sometimes picks up the color unevenly.

19. SHOULD I ONLY USE FINDINGS AS THE MANUFACTURER SUGGESTS?

There are no rules. Use them as you see fit. Sometimes, you'll find a new use for something that's been in your beadbox forever.

20. WILL I EVER HAVE ENOUGH BEADS?

Nope. There is no such thing as a saturation point. I have 35,000 pounds in beads, and I still don't think I have enough.

TOOLBOX

There are certain supplies that are absolutely necessary. Oh, I know, collecting the tools is almost as much fun as collecting the beads. I'm a gizmo person, and I fall in love with the process, as most beaders do; I'd love one of everything, but that's not always possible.

(A)

Whereas we're not all millionnaires and can't go buy everything we'd like, these are the basics that are must-haves for beaders.

PLIERS

These are almost a science by itself. It's overwhelming when you go to the tool department and don't know what you need. When it comes to working with jewelry, size of tools matter. Smaller is better. You can't do precision work when your pliers are the size of a hedge-clipper!

(B)

In the hierarchy of pliers, I would have to say that the **ROUND NOSE PLIER** (Figure A) is the king. This one comes in handy for bending and manipulating, coiling and wrapping. Gotta have this one!

Next comes a good gripping plier, commonly called a **CHAIN NOSE or GENERAL PURPOSE PLIER** - Figure B. It actually wouldn't hurt to have a couple of these - it really saves your nails when you can grip with a plier.

I would say a good **CUTTER** (Figure C) is a real necessity, also - one that cuts close with nice, clean ends. I prefer side cutters to top cutters.

(C)

And, of course, a **CRIMPING PLIER** (shown on page 33). The grooves come in different sizes - you've probably heard of **Micro Crimpers** - these accommodate smaller beads. If you're using standard crimp beads, the **Micro Crimper** is probably the size you'll use the most.

TWEEZERS

It's impossible to knot without a good pair of tweezers. An inexpensive one will do. The best ones come to a point and are smooth inside (they don't have teeth).

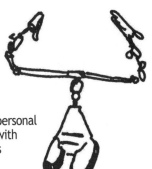

GRIPPING STUFF

I like things that make my work easier. For helping me hold stuff in place, my personal favorites are scotch tape and a device called "A Third Hand". It has two arms with alligator clips at the end, and I wouldn't dream of soldering without one (saves you from getting burned).

TOOLBOX

OTHER STUFF YOU NEED

• **THE SPRINGBAR TOOL** used for watchbands is essential for saving your nails.

• A variety of **NEEDLES** is also important. The silk thread on cards come with a needle already attached. But, if you're using thread from a spool, the needle you need is the **COLLAPSIBLE EYE NEEDLE**. Just as the name says, this needle's eye starts out large and round and easy to thread, but will flatten out and fit through almost any bead. It is made of twisted wire, and is very flexible.

• **ENGLISH BEADING NEEDLES** are extra long and very thin. They're used primarily with seedbeads, but I like to use them to mitigate various disasters, because they weave through existing beads and knots so well.

• A good, **SHARP EMBROIDERY SCISSORS** keeps your ends from fraying.

• A toolbox just for your **SOLDERING TOOLS**. Have lots of stuff to grip with, so you don't get burned. More on soldering on page 48.

CEMENTS & GLUES

• **JEWELER'S CEMENT** (also known as **WATCH CRYSTAL CEMENT**) is a very fine-grain cement that's used on threads because it soaks into the knot and cements from within. Other cements just sit on top and don't hold. Use this for your knots in knot cups, etc.

• **527** or **E6000** are industrial-strength cements that form a great bond metal-to-metal, glass, wood, etc.

FINDINGS

A finding is anything that's not a bead - clasps, etc. Here are a few basics, but you should stock up on anything that looks interesting.

I always figure out a use for something once it's home!

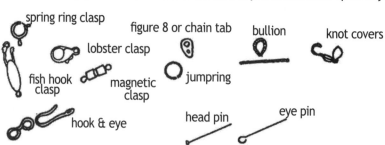

spring ring clasp

lobster clasp

figure 8 or chain tab

bullion

knot covers

fish hook clasp

magnetic clasp

jumpring

hook & eye

head pin

eye pin

ABOUT THE AUTHOR

Wendy Simpson Conner is no stranger to beads. As a third-generation bead artist, she grew up with beads from a very early age. Her grandmother was a jewelry and costume designer for the Ziegfeld Follies.

Being from a creative family, Wendy spent her childhood doing many types of crafts in a rural community. ("There just wasn't anything else to do!"). Over the years, she has mastered many techniques, but beads have remained her first love.

She has worked in several interesting jobs, including as a designer in the entertainment field, and she has a strong illustration background (she always insists on doing her own illustrations).

Wendy taught vocational beadwork classes for San Diego Community Colleges and the Grossmont Adult School District for many years. She now lives in the Los Angeles area and gives workshops. She not only teaches beading technique, but also the dynamics of running your own jewelry business.

Her first book, *The Best Little Beading Book*, was the result of many of her classroom handouts. All of her books, including *The Beaded Lampshade Book, The Magical Beaded Medicine Bag Book, The "Knotty" Macrame and Beading Book, The Beaded Watchband Book, The Chain & Crystal Book, The Beaded Jewelry for a Wedding Book, The Children's Beading Book, The Cat Lover's Beaded Project Book, The Wire Bending Book, The Beading on Fabric Book,* and *The Bead Lover's Bible* have been very popular. They are part of The Beading Books Series™, a collection of 25 books devoted to preserving beading techniques and history. Many of these books are also available in kit form. These kits include the original book, plus materials for making the projects shown.

Wendy designs jewelry for several television shows, as well as the celebrities on them. A frequent guest on many craft shows, she is soon to be the hostess of her own program. There is a series of instructional DVD's planned.

She produced, wrote and directed *The Bead Movement*, the critically acclaimed one hour documentary which examines the world's fascination with beads. This is the only documentary which explains the bead phenomenon. It was an Oscar Qualifier, and premiered at the Music Hall Theatre in Beverly Hills, California to a packed theater.

This is also available in a 27 minute director's cut. Both versions have won several film festivals.

Wendy is available to teach workshops. If you are interested, please contact her through the Interstellar Publishing Company, Post Office Box 7306, Beverly Hills, CA 90212.

If you have any beading questions, you may email them to Interstlr@aol.com.

INTERSTELLAR
TRADING & PUBLISHING COMPANY

Other Beading Books, Kits, and Videos By the Interstellar Trading & Publishing Company:

The Best Little Beading Book • The Beaded Lampshade Book
The Magical Beaded Medicine Bag Book
The "Knotty" Macrame & Beading Book
The Beaded Watchband Book • The Chain & Crystal Book
The Beaded Jewelry for a Wedding Book
The Children's Beading Book
The Cat Lover's Beaded Project Book • The Wire Bending Book
The Beading On Fabric Book • The After 8 Elegant Jewelry Book
The Bead Lover's Bible • The Beaded Tassel & Fringe Book
The Beaded Doll Book • The Beaded Projects For Your Home Book
The Holiday Beading Book • The Beaded Purse Book
The "Knotty" Macrame Kit • The Beaded Watchband Kit
The Magical Beaded Medicine Bag Kit • The Children's Beading Kit
"The Bead Movement", a one hour documentary about beads
"The Bead Movement/Director's Cut" (27 min.)

Children's Books:
Princess of the Moon • Stuff, Stuff, I Want More Stuff

If you would like a catalog of other titles and forthcoming books
from the Interstellar Trading & Publishing Company, please send
a stamped, self-addressed envelope to:
THE INTERSTELLAR TRADING & PUBLISHING COMPANY
POST OFFICE BOX 7306 • BEVERLY HILLS, CALIFORNIA, 90212

800-790-8730 • Interstlr@aol.com
visit our website at www.interstellarpublishing.com